William Scharf

Paintings, 1984–2000

Preface by Eliza Rathbone

Essays by Hilton Kramer, Harry Rand and Brian O'Doherty

The Phillips Collection, Washington, DC

November 18, 2000 – January 21, 2001

This catalogue was prepared in conjunction with an exhibition
held at The Phillips Collection, November 18, 2000 – January 21, 2001

Published by The Phillips Collection
1600 21st Street, NW, Washington, D.C. 20009

Library of Congress Cataloging-in-Publication Data

Scharf, William, 1927–
 William Scharf : paintings, 1984–2000 ; exhibition held at the
Phillips Collection, Washington, D.C. November 18, 2000 – January
21, 2001 / with a preface by Eliza Rathbone and essays by Hilton
Kramer, Harry Rand and Brian O'Doherty.
 p. cm.
ISBN 0-943044-25-1
 1. Scharf, William, 1927—Exhibitions. I. Kramer, Hilton.
II. Rand, Harry. III. O'Doherty, Brian. IV. Phillips Collection.
V. Title.

ND237.S4214 A4 2000
759.13—dc21
 00-049146

Edited by Johanna Halford-MacLeod

Design: Marcus Ratliff
Composition: Amy Pyle
Digital photography and color separations: Martin Senn
Photography: David Allison, Gavin Zeigler
Color imaging: Center Page
Lithography: Meridian Printing

Cover: William Scharf, *Pink Annunciation*, 1985

Preface

William Scharf: Paintings, 1984–2000

THERE IS something exhilarating about presenting to the public forty-three paintings by William Scharf, an artist who is too little known. Once introduced, I believe viewers will not soon forget this work. Some paintings are wall-size but remain intimate; others are small enough to hold in your hand but large in concept. I have seen Bill Scharf's paintings over a period of about twenty years in periodic studio visits. His vision seems only to have intensified in recent years, and many new works come as a revelation.

It is not only Scharf's expressive use of color that gives his work a natural place in The Phillips Collection, a museum he has visited often. His strange and marvelous images and their unique palette transport the viewer to uncharted realms, offering the experience of "escape" in art that Duncan Phillips valued so much. Scharf's knowledge of the power of color and composition to evoke mood and meaning can equally well remind us of such key figures in The Phillips Collection as Albert Pinkham Ryder and Arthur Dove. His sense of the mysterious and the elemental forces in man and nature makes him their ally. Although certain imagery such as a ladder or a crown of thorns might specifically evoke centuries of Christian art and iconography, these symbols are liberated in Scharf's painting from any traditional context to be reinvested with meaning, regaining in effect their authenticity or claiming a new one. Scharf finds stimulation in art of the ancient world as well as more recent epochs. Today the

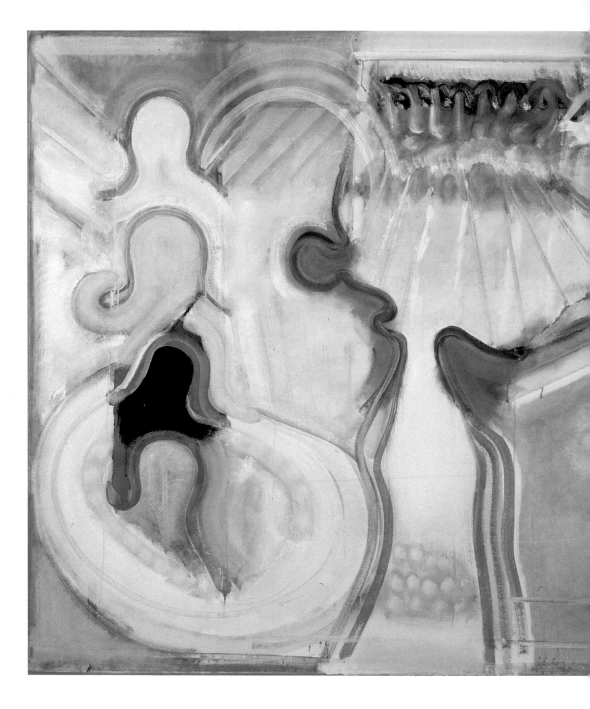

Cerebration, 1984

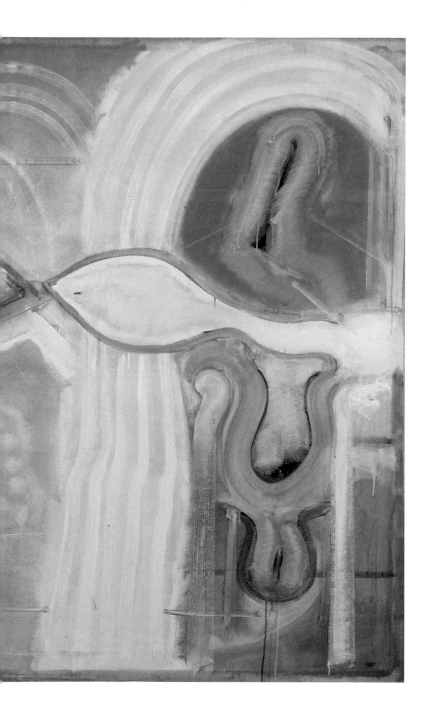

Metropolitan Museum of Art, a short distance from his studio near Central Park West (a seventeen-minute walk, he tells me), is a constant destination.

How does one introduce succinctly an artist who has been working for fifty years exploring, developing, refining, and strengthening his unique artistic voice? In paintings from earlier decades, one already finds an intensely realized inner vision—dark compositions dominated by reds and blacks, offset by luminous white, pink, and violet forms that glide, dance, or worm their way through these images. Line, color, and form marry titles that amplify our visual experience and resonate with the sense of a private meditation interrupted. Where do these titles come from, with their obscure references and enigmatic elisions? Sometimes we are simply seduced or swayed by the sound of the words themselves, as Scharf indeed must be. They seem to weave their way into the events of his paintings, ultimately leaving us with a sense of the unexpressed or unexpressable.

We also find in Scharf's work echoes of surrealism reminiscent of Arshile Gorky. Scharf's sinuous line and suggestive forms seem to live on the surface of the canvas, communicating inner feelings and emotions that sometimes extend from terror to ecstasy. And we can feel sure that Scharf, in his embrace of poetry and reluctance to define a symbol, would agree with Gorky's conviction that the viewer can and should find his or her own meaning in the work, which will inevitably "relate to or parallel" his. Scharf's eloquent range and depth of thinly applied veils of color might signal to us his time spent as the studio assistant to Mark Rothko in 1964. But his desire to use a full spectrum of line and gesture, color and form, endows these paintings with a concentrated dynamism more akin to Kandinsky. When looking at Scharf's paintings, we are reminded of André Breton's "convulsive beauty."

On many occasions I have been welcomed by the Scharfs in their apartment on Central Park West. A long wall across from the

fireplace is always hung with one of his paintings. Other walls too. Bill Scharf first showed me his work here using this long wall, unrolling each large canvas and, armed with ladder and staple gun, affixing them to this support, one after another. When I subsequently visited him in the cramped subterranean studio he occupied for many years, it seemed miraculous to me that paintings so large in size and scope could be produced there. Though small, Scharf's new studio offers views north and east and the pleasure of daylight. By now a master at working in a confined space, he still keeps most of his canvases rolled, waiting to unfold their many splendors on an occasion such as this.

Rarely do The Phillips Collection's paintings by Rothko leave this museum as they have now for an important exhibition abroad. It seems fitting that Scharf, who since his early *Continuum* series has conceived paintings that take the place of walls, should occupy this space and adjacent galleries in Rothko's absence. That he and Rothko were close friends offers further cause for celebration.

I am extremely grateful to Hilton Kramer and Harry Rand, both of whom have long admired Scharf's work, for their insightful contributions to this publication. I would also like to thank Kate Rothko Prizel and Ilya Prizel for lending their beautiful painting *Cerebration* and Brian O'Doherty for allowing us to reprint his 1993 essay, which I have always admired. Johanna Halford-MacLeod, with the help of Mary Hannah Byers, coordinated the myriad details of this catalogue, which was edited by Lisa Siegrist. I am delighted that Marcus Ratliff, who designed pamphlets for two of Scharf's earliest shows in New York, could bring his experience to help us so ably with this publication. I am especially grateful to Bill Scharf for sharing his work with all of us.

Eliza Rathbone
Chief Curator

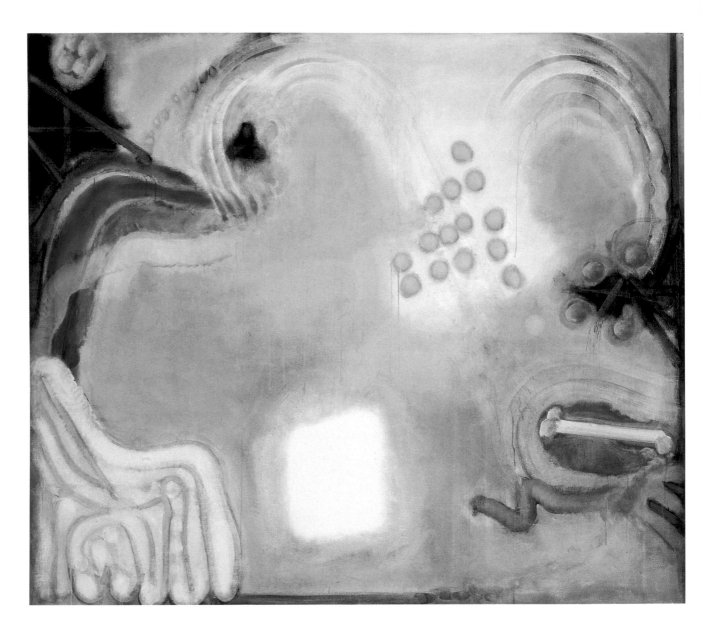

Bruised Emanation, 1984

The Paintings of William Scharf

Hilton Kramer

He seeks as image a second of the self.

—Wallace Stevens, 1947

THE PAINTINGS of William Scharf offer two distinct orders of pictorial experience. One is exuberant, expansive, even operatic in its sweeping gestures, effulgent color, and bold painterly structures. The other is a kind of chamber music in which the same vocabulary of feeling—a lyricism tending toward the exotic—is concentrated in a smaller, more intimate space. In whichever scale the paintings are conceived, they articulate a vision that is at once highly original—in the sense, that is, of resembling the work of no other painter I know—and yet clearly belonging to what is now recognized as an established tradition, the abstract expressionism of the New York School.

It is with the work of the early years of the New York School that all of Scharf's recent paintings have their closest affinities—the period in the 1940s when "subjects of the artist" were themselves a much-debated subject among a rising generation of abstract painters. This was a period in which myth and ritual, the primitive and the archaic, and concepts of the sacred based more on poetry and ethnology than on theology were advanced as appropriate "subjects" for a mode of abstraction that abjured both the representation of recognizable objects and the restrictive geometry of constructivist form.

As may be inferred from the titles of certain paintings—among them, *Orchard of Fables*, *Stigmata of the Thorns*, *Pink Annunciation*,

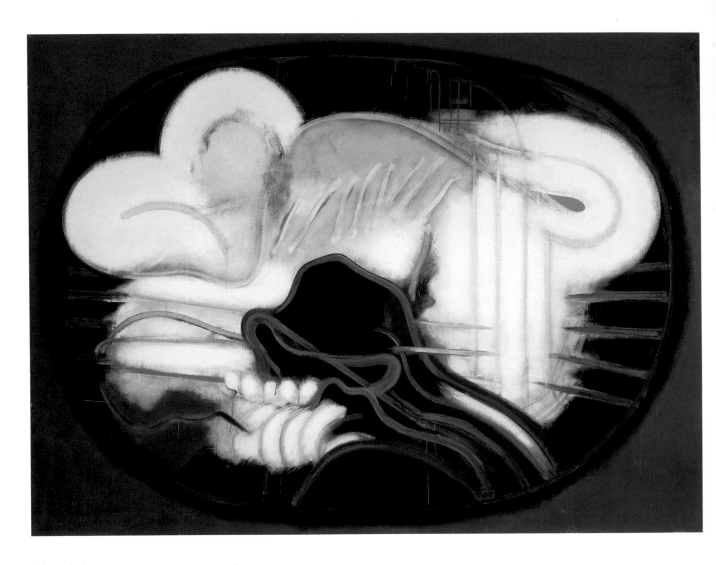

Sphynx Cloud, 1992

Bejeweled Rite, and *The Martyr's Ladder and the Harm Angel*—
Scharf's pictorial vision is similarly informed by an interest in myth
and a search for transcendence. The light in these paintings—eerie at
times and dreamlike in its evocation of a haunted imagination—is not
to be mistaken for the earthly light of common experience, nor is nature
rendered in any of its familiar aspects. Yet these are paintings crowded
with distant allusions to dawns and dusks and chromatic events that
might be construed as celestial gardens or imaginary galaxies. They
transport us to unfamiliar realms where the momentum and metamor-
phoses of human experience are translated into the artifice of abstrac-
tion. Seeing Scharf's paintings again on this occasion, I am reminded
of some further lines in Wallace Stevens's "Three Academic Pieces,"
from which I have drawn the epigraph to these observations:

Here the total artifice reveals itself
As the total reality

It is, of course, the mark of a first-rate talent in any art to be able to
establish its artifice as an irresistible reality. The critic R. P. Blackmur
made the same point many years ago when, in speaking of a certain
kind of achievement in poetry, he said that it "adds to the stock of
available reality."

All of which places the art of William Scharf in the main current of
modernist painting, which, despite all the talk of postmodern this and
that, still accounts for most of the best painting of our time. Recently,
in the *New Yorker*, a critic I usually admire—Joan Acocella—wrote
that "modernism will surely go down in history as the most austere,
self-denying style ever invented by the Western mind," and with this
doleful, mistaken judgment I must respectfully disagree. Modernism
is not, after all, a single "style," but a constellation of rich and often
conflicting styles and anti-styles, which are not to be dismissed as uni-
formly "austere" and "self-denying." This wasn't true of the particular

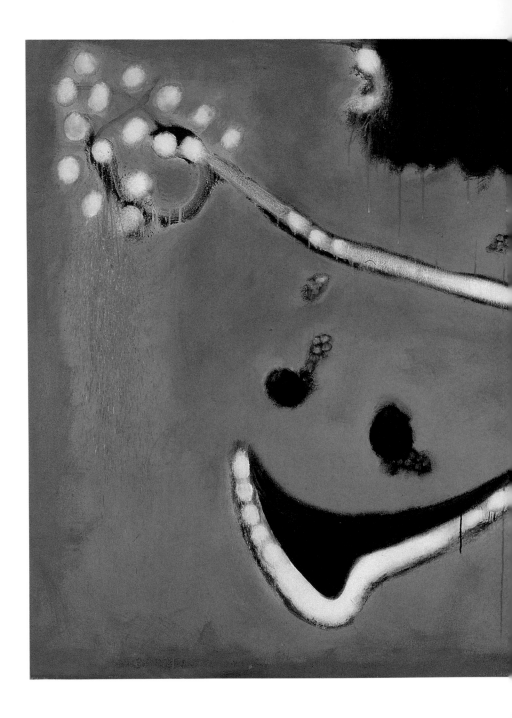

Pink Annunciation, 1985

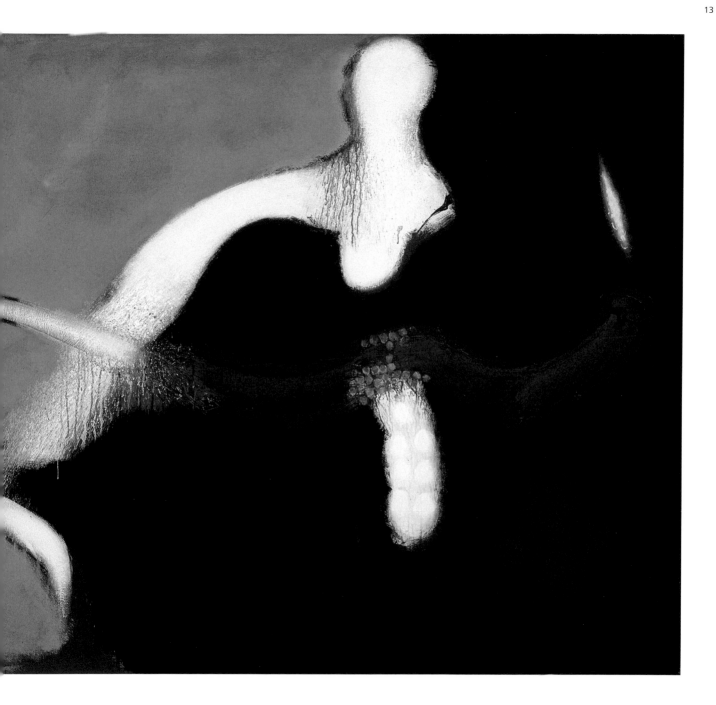

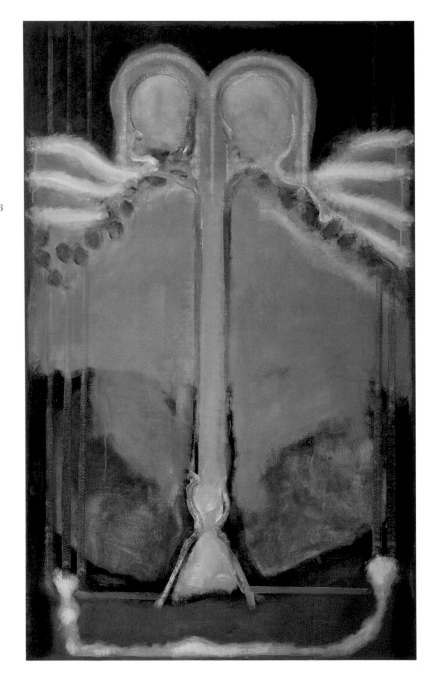

By Mirrored Meaning, 1993

chapter in the history of modernism we now refer to as the New York School, and it certainly isn't true of the paintings that have been brought together in this exhibition, which, far from being "self-denying," indeed constitute "a second of the [artist's] self."

William Scharf's personal odyssey as an American modernist is itself a story that ought to be better known as part of the folklore of the artistic life of his period. He was born in Media, Pennsylvania, in 1927—which places Scharf in the same generation as Joan Mitchell (born 1926) and Helen Frankenthaler (born 1928), Robert Rauschenberg (born 1925) and Jasper Johns (born 1930), all of whom, in their very different ways, found themselves obliged to deal with the legacy of the abstract expressionist aesthetic. As a boy of ten, Scharf showed his drawings to N. C. Wyeth, who responded with enthusiasm and gave him art supplies. Seven years later, Wyeth facilitated the young Scharf's admission to the Pennsylvania Academy of the Fine Arts with a recommendation that boldly declared, "This boy has the stuff."

After a stint in the U.S. Army Air Corps, Scharf returned to the Pennsylvania Academy and also took classes at the Barnes Foundation and the University of Pennsylvania. His first European travels, which included study at the Académie de la Grande Chaumière in Paris, came in 1948–49. He worked as a seaman on a tanker, traveling to South America, and as a clown diver in an acquacade in Florida before settling in New York in 1952. It was there that he met Mark Rothko in 1953.

Just as his friendship with N. C. Wyeth sustained the young Scharf at the outset of his career, his even closer friendship with Rothko in the last years of the latter's troubled life did much to strengthen Scharf's own artistic convictions in the years of his maturity. In the 1960s he assisted Rothko in the early stages of the latter's mural project for the De Menil Chapel in Houston, Texas, and in the 1970s, in the aftermath of the legal problems over the Rothko estate that erupted after the artist's death in 1970, Scharf was appointed to serve as an officer of the newly

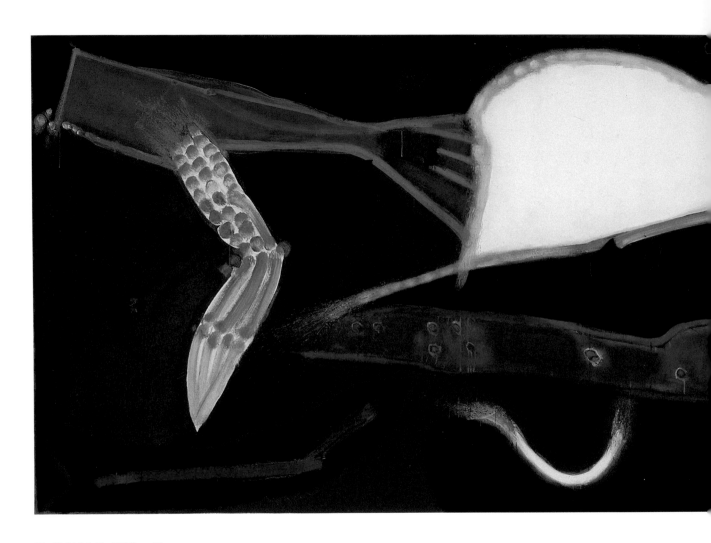

The Night Is in the Middle, 1986

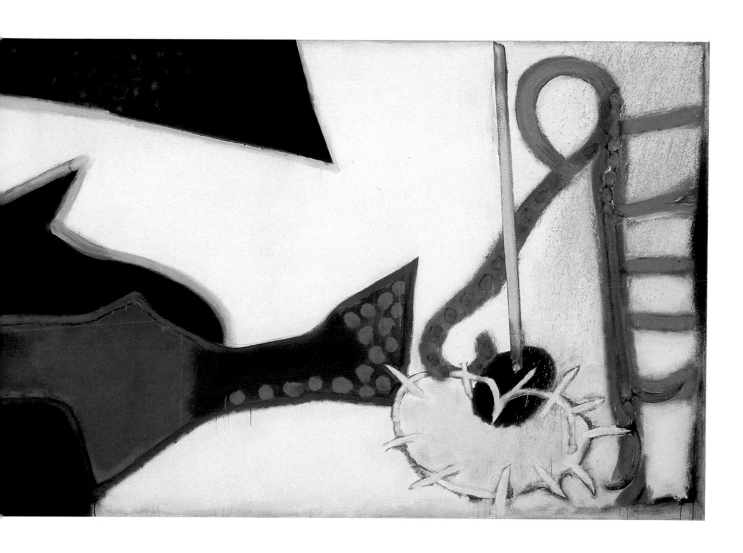

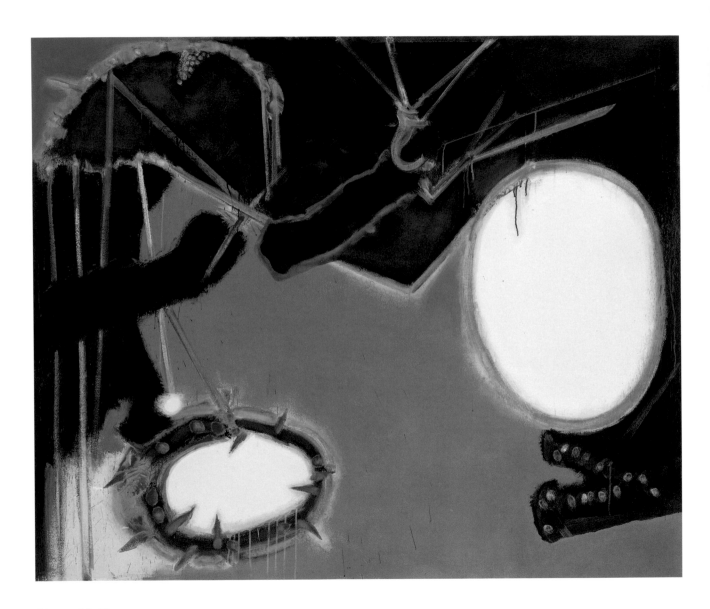

Stigmata of the Thorns, 1993

created Rothko Foundation by the attorney general of New York State.

Yet, through this sometimes turbulent period in Scharf's own life, he remained steadfast in his pursuit of an artistic course that remained undistracted by the shifting fashions of the day. While his exhibitions were often favorably reviewed by the critics, he has never been the kind of artist who openly courts public attention. As a consequence, he remains better known today to certain artists and critics than to the throngs that crowd the latest blockbuster shows and reserve their enthusiasm for the latest sensation.

As long ago as 1962, one of these critics—Dore Ashton—gave us an account of Scharf's essential outlook on art and the sensibility that nourishes it, which requires no amendment nearly forty years later. "He is an abstract artist," wrote Ashton, "but he belongs to the family of artists, among them Odilon Redon, that is drawn to the phantasmagoric, the increment of their own disquieting dreams." Artists of this persuasion take us on an inward journey of the mind, where every shape and shift of light and shadow and what another critic—Vivian Raynor—once described as "controlled explosions of molten paint" assume a symbolic significance that is resistant to easy definition. These are paintings that invite us, too, the viewers, to make a similar journey in our effort to apprehend their meaning and enjoy their complex pleasures. In this respect, they return us to the pleasures and profundities of high modernism, which makes demands on the imagination—both the artist's and ours—that is one of the glories of the art of our time.

It is therefore fitting that this beautiful exhibition should be mounted at The Phillips Collection, which was founded as the first art museum in the United States to be devoted to the achievements of modernism and whose permanent collection contains so many excellent examples—the paintings of Albert Pinkham Ryder and Mark Rothko among them—of an art that is directly antecedent to these paintings by William Scharf.

Shields of Falsity, 1993

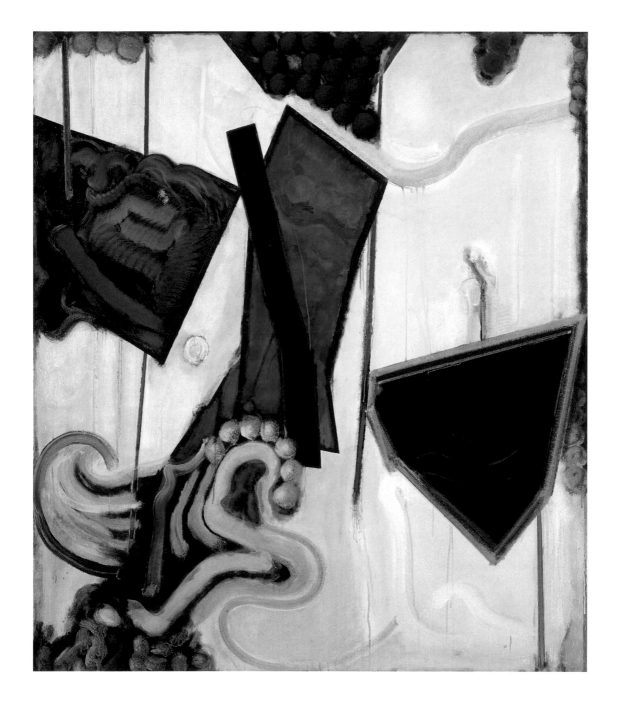

Apotheosis of the Wing, 1995

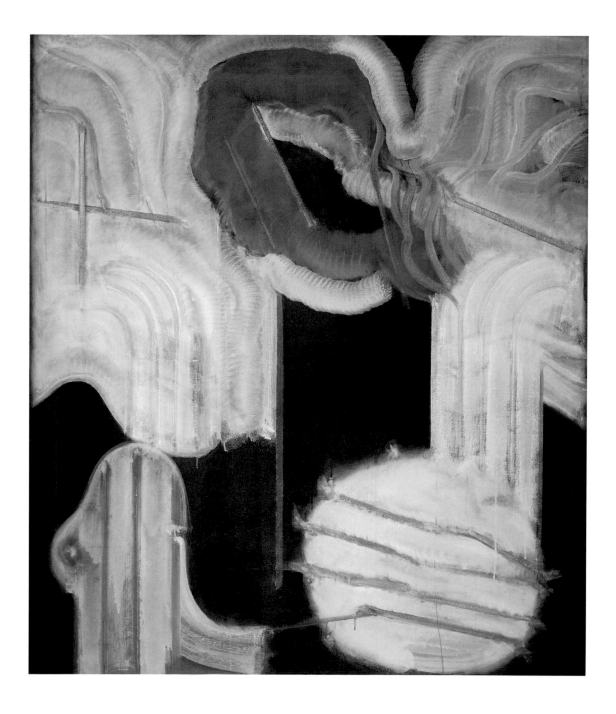

Above the Milk Sphynx, 1994–98

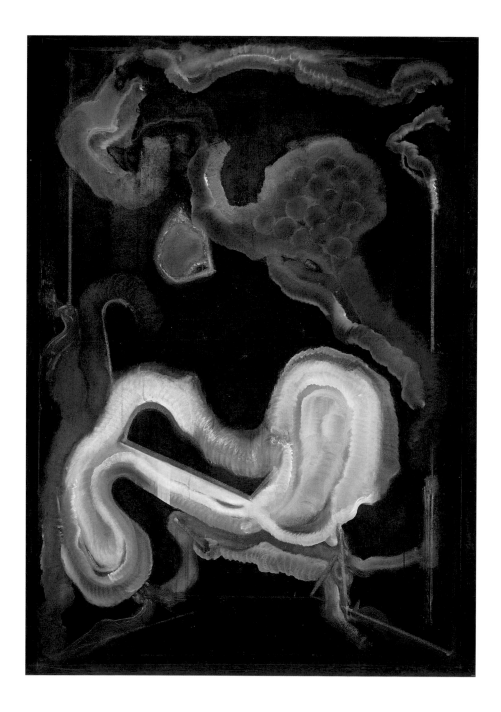

Bejeweled Rite, 1996

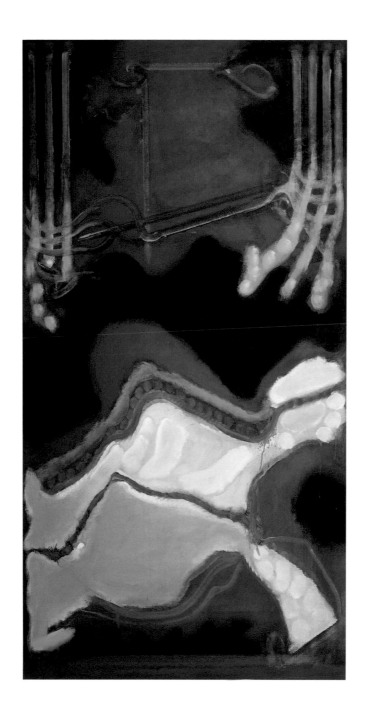

Orchard of Fables, 1998

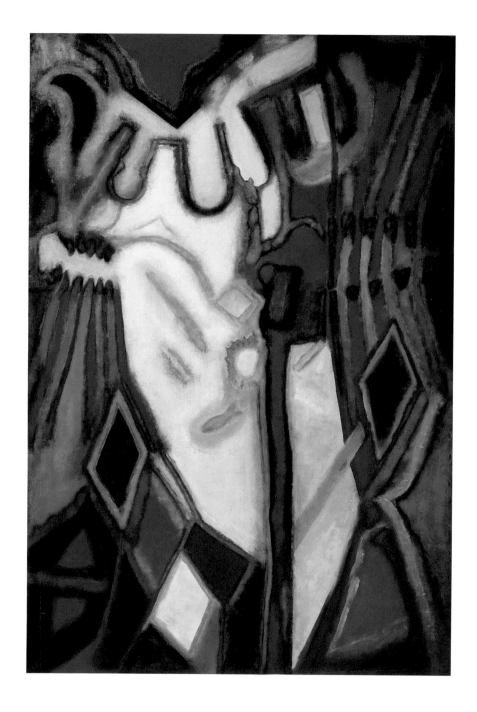

The Martyrs Ladder and the Harm Angel, 1998–99

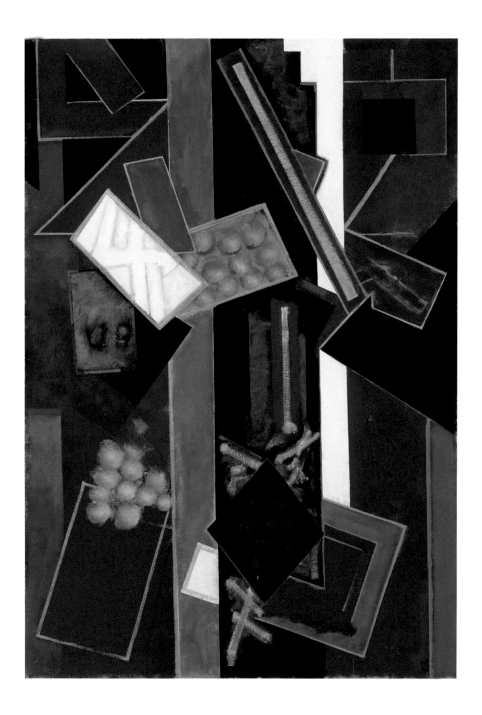

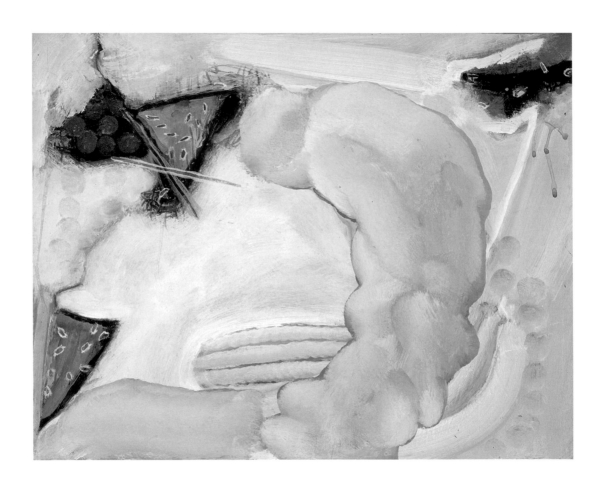

Of Valued Folly, 1989

William Scharf: History Painter

Harry Rand

THERE IS A SOLID substrate if you scratch back the loam. Unfashionable to claim such firmness exists, we tread on it to the horizon, even those who doubt and walk in circles. Despite the charming naysayers' witty denials, a foundation of artistic quality perdures. That groundwork conforms to one of two models: Either modern art is evolutionary or revolutionary. It either grew from what preceded it in small replacements of assumptions (as minerals replace tissue in a fossil) or radically broke from the past (e.g., "Cubism was not inevitable"). This choice conditions expectations for modern art, especially that art known as "abstract" or "nonobjective." The problem with positing either of these theories—the *ex nihilo* or the plodding uniformitarian—is that the sensation of quality must be addressed. Either way, art has to measure itself against what went before, however it came into being. There is no appreciation of quality without former experience, a proposition William Scharf tests and proves in every work.

If evolutionary, modern art must explain itself by replacing its ancestor (Oedipally, perhaps, but murderously in fact), and if revolutionary by successfully competing with the body of encounters remembered and felt. Either way it's murder or suicide for serious art. There is no gainsaying the experience of quality. There's no side-stepping this issue, because if art is not pleasurable in its intellectual play of forms and those forms' solicited recollections, not a delight

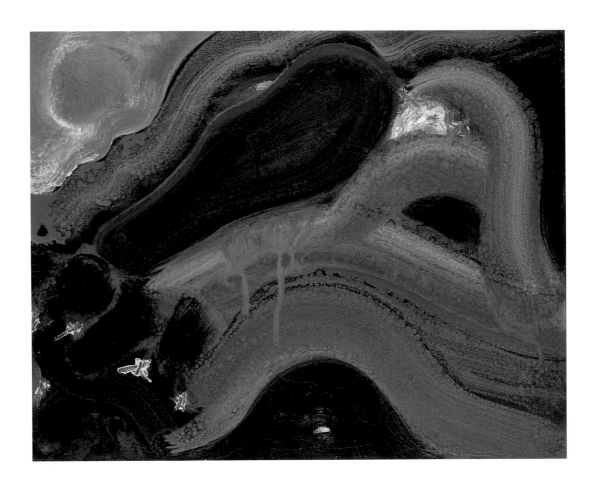

Grey Moon, 1991

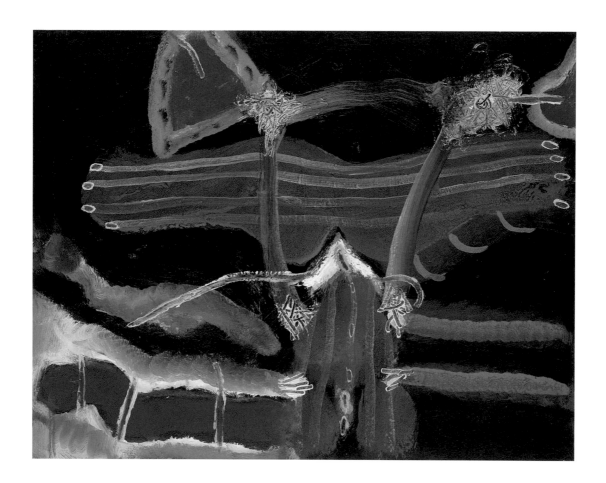

Hate Lifter, 1991

in shape and color (good color is not pretty color), not interesting in scale, not ennobling, then what's the point? Avoiding this enormity is for (1) the lazy or uninterested, or (2) dealers (no dealer ever sold a bad painting). The ranks of the lazy count just about everybody in times of lax language. They are not apt to befriend William Scharf's art. Among the uninterested are investors posing as collectors and their journalist cheerleaders and, among the higher reaches of most art museums in the last few decades, many directors and boards. (Dealers remain just that, neither friends nor expected to be.) These often vociferous and easily wounded people do not care, or, in Charles Olson's words, "Hail and beware the dead who will talk life until you are blue / in the face." Before real art we can feel abject or exultant, not at the melodramatic bluster of promoters imploring us to feel so much more than is evident—or worse, to not care. There is nothing cool or hip, withdrawn or posed about William Scharf's work. A painting like *Bruised Emanation* is not a stance struck but the successful ascent of a difficult and rarely achieved summit. That he is not better known at this time has no effect whatsoever on the results. He is not in the race for present fame.

The best or most serious art called "abstract" or "nonobjective" measures itself against the best of the past and does not contest last season's "shocking" but utterly comfortable conceit. You will look in vain for anything fashionable in *From Darker Aims*, but you will also find nothing in it that fails or declines from the most elemental. There is no ornament here, nothing added to the necessary constituents, and there is nothing in vogue.

Some artists aim to match or exceed a transhistorical standard rather than simply dazzle their contemporaries. This is a large gamble—to go into the grave unsung. Some work of the last few decades has actually passed the historical test—not a trivial achievement for only a century of this art. (The entire Renaissance was

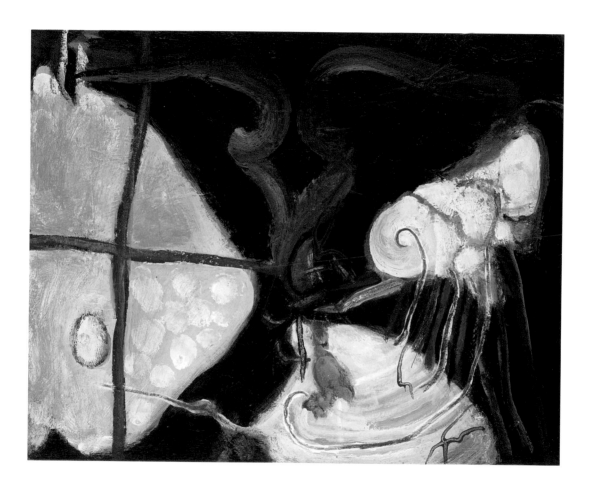

Flesh Jail, 1991–94

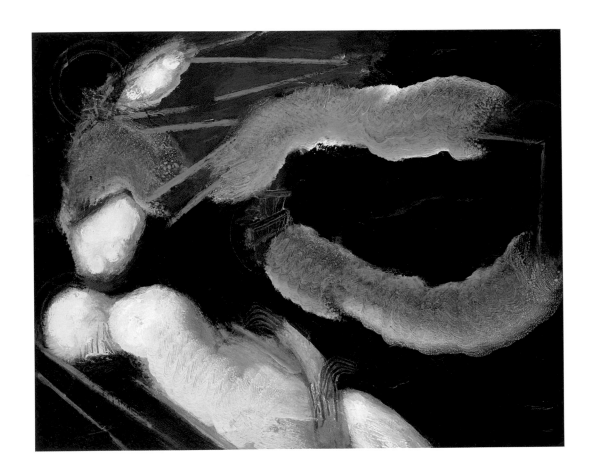

From Darker Aims, 1994–95

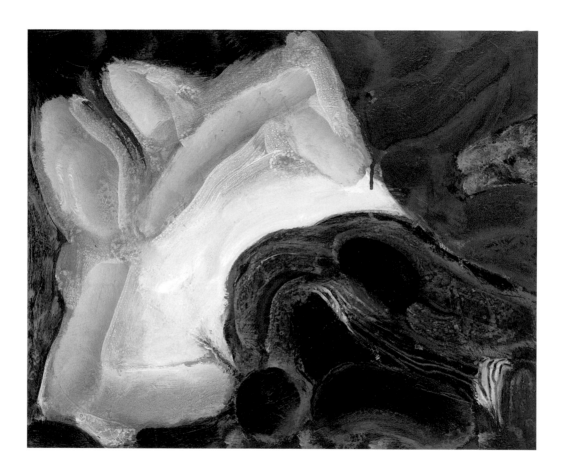

An Asgardian Again, 1994–95

only twice as long as the history of modern art so far.) The major question for reputable artists—those who do not paint with their tongues, rely on the agreeable intimidation of a coterie, or surf a passing fashion—is how to find sufficient occasion to paint grandly. William Scharf can convince us of that opportunity taken in a compact picture such as *The Angels Say No to Fra Angelico*, with its hint of a spacious landscape part Sassetta and part early Kandinsky, dreamers both. The implicit narrative seems the best and truest instinct Scharf inherited from his decade-long association with N. C. Wyeth.

There have been very few—a handful, really—ways to stock an abstract work with the abundant (not necessarily numerous) visual incidents available to history painters. Despite its title, *Pink Annunciation* recalls history painting. Depth and seriousness of purpose once had communal and shared names, which, in the immediate past and still-haunting last century, fell away; now artists invent the names for stories. William Scharf's titles are the least interesting aspect of his work, suggesting blind alleys of association, impossible-to-keep appointments. Unique shapes and compositions cannot be uttered. Some of Scharf's small pictures, *Alee of Vikings* or *From Darker Aims*, seem glyphs in a lost language or minor players waiting to be called upon the main stage of his larger works. All are part of a flow, a story told in another country, a tide retreating at night, history painting of somebody else's central epic. Everything depends on the art because for us William Scharf's subjects have no names.

There is no question that this latter concern, how to provision a surface with meaningful graphic interludes, has propelled the best abstract art from Cézanne through Gorky and Pollock to Rothko and early Stella. It is also the driving force, principal question, and the challenge for William Scharf.

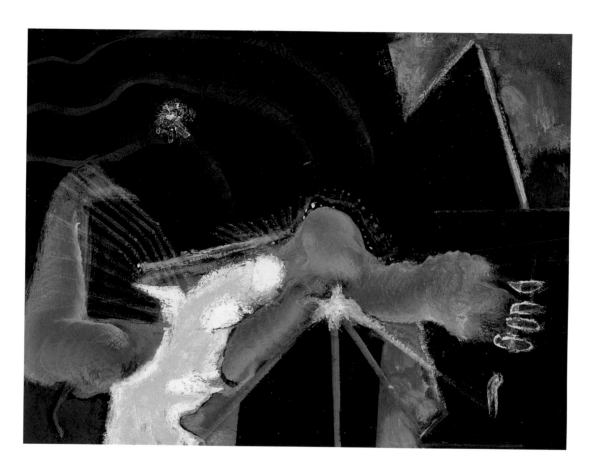

The Angel Says No to Fra Angelico, 1995

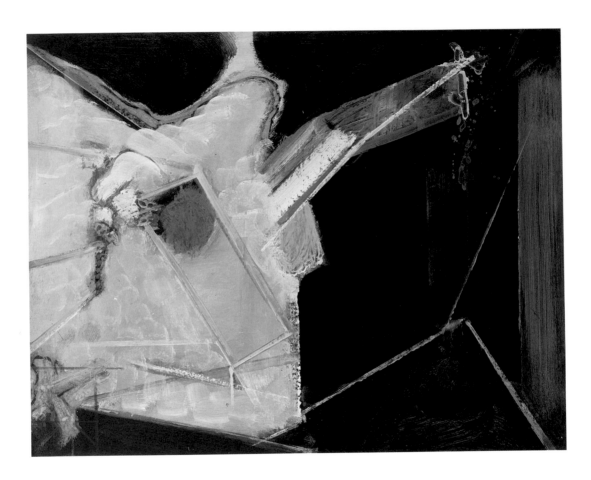

The Prodigal Daughter Returns for Her Mirror, 1995

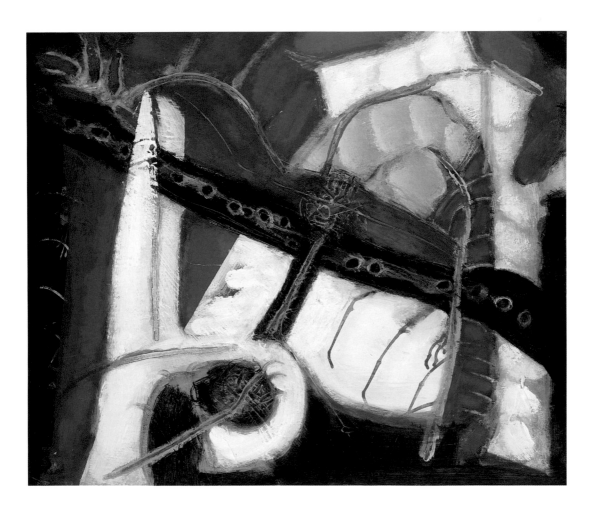

The Denials Defied, 1997

There seemed two ways to gain the ambient gravity, seriousness of tone, and visual solidity of history painting without using (not to say relapsing upon) the images of occidental realism. (Let us stipulate also that size is not the answer; many an abstract artist has floundered and an audience has been conned with gargantuan expanse for no pictorial reason. This is not Scharf's problem because many of his best works are diminutive, but so were Corot's.) Abstract art has gained the semipermeable screen created by the swirls and drips of painters exploring the physical properties of their medium. This was Pollock's additive approach (not a method of painting), which has also served Jules Olitski, Milton Resnick, and, for a while, Philip Guston, furnishing densely contiguous images with an implied—though unspoken (or unspeakable, nondiscursive)—rationale. Technique is not the issue. The technique of *Apotheosis of the Wing* is not surprising, only its effect. William Scharf's technique is mainly invisible and uncontroversial. He uses black as a color and not as a symbol.

How to make a work that counts, that matters, and that continues to signify and suggest? A reductionist or even a minimalist approach marked the work of Rothko, Gottlieb, and, to some extent, Reinhardt. (This minimalism had nothing to do with doctrines like Malevich's suprematism or Mondrian's neoplasticism, which *design* the surface of the painting.) Laying out this two-pronged assault on historical quality reveals William Scharf's sympathies: he is not a descendant of Monet but of Poussin, and there is more of Benjamin West in Scharf's work than Malevich.

Piling up details is not the issue when countering the machines of history painting or the many significant details of a portrait. *Copper Honor* can be dissected; it has sections that are not additive but integral. At the core of the whole modernist enterprise is the taste for authenticity, for the thing not confected of inherited parts

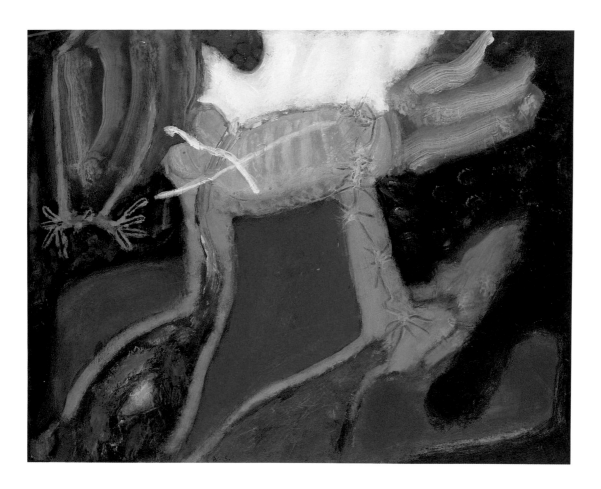

The Sun Blued Moss, 1997

but springing to life meaningfully from the artist's experience.
Here we recall the entirety of Gilbert Sorrentino's poem of a single
three-line stanza:

Something plus something is not one thing.
An insufferable vicious truth.
One lives with it or one dies. Happy.

So William Scharf proceeds. Ideas cascade from him with the
regularity of a shrewd diarist, and these various images settle
eventually into paintings. No one will ever fault his imagination's
fecundity. He sketches, then his images are redrawn, altered, planned
as an ensemble, elevated from drawings (sketches as meticulous
as the Victorian observations of an alpine hiker), and entered into
paintings where we cannot retrieve their occasion but marvel at
their profusion. Such richness is usually a young painter's, yet
William Scharf keeps it up, somehow. The details precipitate into
paintings from an imagination stocked to overflowing, and his
success is achieved as parity with representation. These works
are the antonyms for charm or gaiety. William Scharf's painting is
all astuteness.

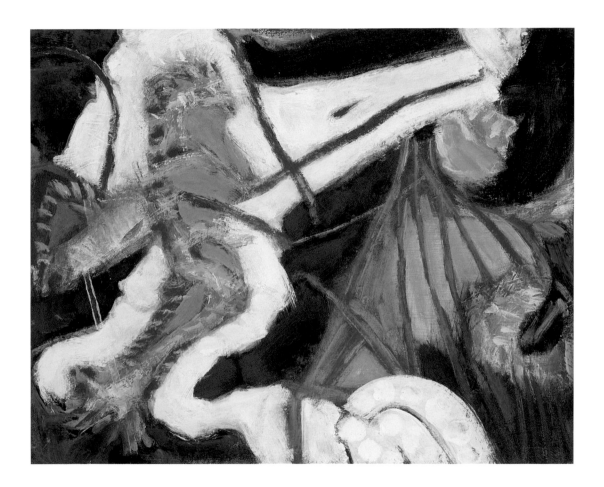

A Phoenix for Finding, 1998

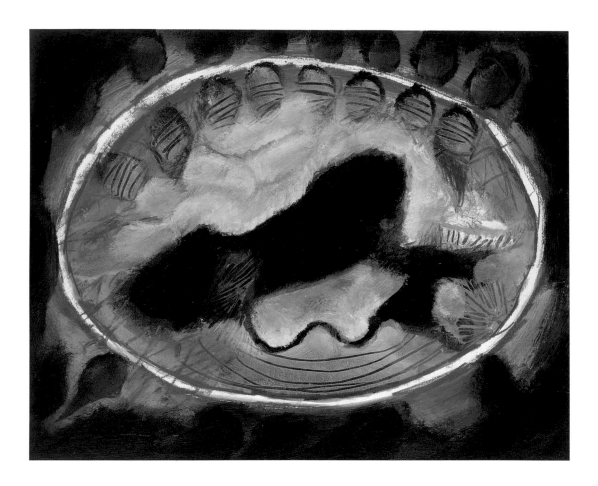

Wind Oval, 1998

William Scharf: The Long and the Short Eye

Brian O'Doherty

IS WORK OF great value in many fields involuntarily excluded from our awareness? The instinctive answer is No. We—our arrogance prompts us—know everything and we know it now. Nowhere is our knowledge more prideful than in the visual arts. We rebuke previous ages for their obtuseness, and forgive them because a different social history was in operation. The future existed back then and rediscovery was safely consigned to us who occupy it. Now the future is devalued, certainties dissolved in relative contingencies, and our consciousness has spread over every slippery surface. If an artist of magnificent gifts could escape this powerful and searching awareness, our pride would be humbled.

Can we premise an artist who has escaped notice, who has withdrawn from, rejected, ignored or otherwise avoided the sanctioned routes through which a sought-after artwork must make its curious way? Can we visualize an artist with a sophisticated knowledge of the process, but who is not a part of it? Who feels that recognition—which inevitably involves endorsing esthetic value with the value of money—is often corrupt? Someone free of that Faustian yearning for fame?

Eighty years ago, perhaps Bonnard would serve as an example. Younger than his colleagues, Bonnard was first seen as a tardy Impressionist, a too-late comer, until the work made its case to more perceptive and open eyes. Now the radiant work of at least one artist falls into this category—or rather, rises splendidly out of it. William

Scharf, of whom I am here speaking, was younger than his abstract expressionist colleagues. He was an intimate of some leading members of the group, and he has been following up, with ever more glorious results, the lessons learned back then—so that he could, over the succeeding forty years, forget them. His paintings now confirm the achievements of the generation to which he—by habit of mind and esthetic—belonged. Each artist's mature work is deeply implicated in the sets of problems he and his generation faced, rejected, transmuted, reformulated. At a certain point these cues, which bind a group together and sustain their inquiry, are discarded as each artist launches himself or herself into an open field. Though eventually the work may look very different, some common attitudes are always decipherable.

Finding William Scharf's work has a somewhat eerie element of surprise. It answers a question one had not asked. What if a younger member of the first abstract expressionist generation had carried their work further in scale and complexity while remaining faithful to some key aspects of his interests? Scharf's answer offers that uniqueness that we, with our fetish of originality, so highly prize.

During a routine perambulation in the role of a *New York Times* critic in the early sixties, I first came across Scharf's work, and I had not forgotten it. Those early scenarios possessed a content all the more urgent because masked in suggestion, ambiguity and forceful equivocation. As I remember them, some thirty years later, they were very personal, but who that person was remained unanswered. They were autobiographical without biography, familiar, but evading recognition. The pedigree, if not the narrative, was clear—the now legendary *frisson* between surrealism and abstraction, mediated by a painterliness that in these paintings (my memory may betray me here) partially censored its desire with an anger for which the cliché qualifier "smoldering" seems exactly apt. W. B. Yeats once described

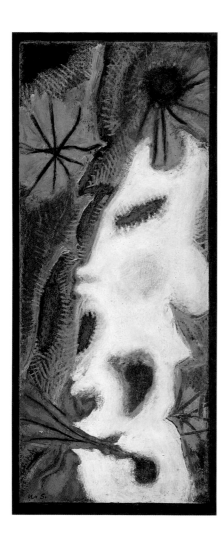

From Blind to Broken, 1999

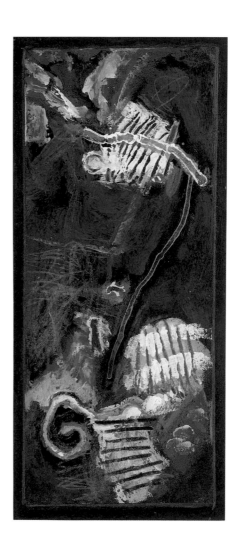

The Cancelled Ladder, 1999

a colleague's prose as "close, crabbed and passionate." That phrase, I remember, came to mind.

Memory is an antic faculty, stocking its attics and vaults with useless bric-a-brac retained for no obvious cause that reason, taking them out and inspecting them, can find. Memory also retains some valued things it keeps polishing and refreshing according to the orders of a similarly obscure logician. I never forgot those paintings. They fused into a single image that hovered in memory's space—a darkness in which their colors shone like stained glass.

I didn't see the work again for two decades and when I did, the paintings burst out of their extended formats in narratives so demanding, in colors so fuliginous, that they negotiated bluntly with the memory image of the previous work. There were great differences—an amplitude that extended the canvas laterally to a width/height ratio of about three to one; an assured ease in searching for the subject, and a confidence in testing it to bring it home; an untangling of the somewhat sullen centripetal matrix I remembered. The work was more beautiful and ambitious, its energies flowing in loops and jagged shapes, stopped by harsh edges or bleeding into an ambiguous figure-ground. It was as difficult as ever to decipher, but the urge to do so was even more profound.

Immediately, for those mysterious reasons that the mind involuntarily offers, it reminded me of poetry—the poetry of Dylan Thomas, perhaps: the clusters of generative imagery, the ebullience, the epigrammatic compressions, the logical core buried in a surreal image, the diction that is a form of wit, the love of nature, the supple mythic reach, the insistent rhythms as they roll towards origin. The creative process (that much maligned manufacturing faculty) which in these works occasionally paused to study itself, was superimposed on a search for a creationist myth. Where, I thought, had those paintings been? Their author has not exhibited much eagerness to show them.

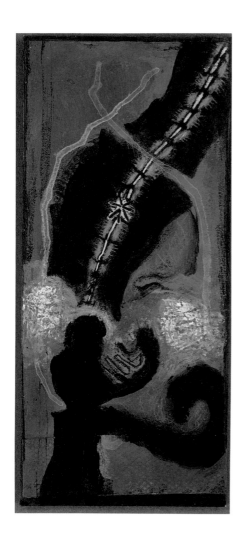

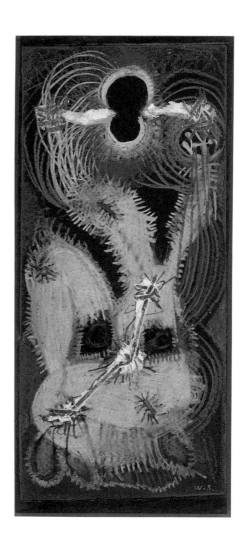

Under a Rightening, 1999

The Profaned Fleece, 1999

What did I know of Bill Scharf? A gentle man with a fiery nature, frequently met in Central Park on his way to or from the Metropolitan Museum; a great reader with strong literary passions, generous to other artists, firm in his convictions, mad about painting, and always on the side of the angels. Rothko, particularly, admired him even as Rothko moved towards reduction and Scharf moved towards extended and complex narratives. I first saw the works unrolled in a narrow space so that the paintings almost surrounded me; the first impression was of an opulent and ravishing color with a great range of mood from spring freshness (light greens and blues) to sultry darkness (reds and blacks). It wasn't easy to get the relation of part to parts and parts to whole at first, lacking the distance to settle them down. Perhaps because of that, the poetry analogy remained in my mind. The parts were, like words, lines or stanzas, polished in situ, then related to others as the synthetic work of rhyming and alluding went on across the painting. The risks were high—at least to me. The prestidigitation required to keep several things in the air (air and water being the usual spatial references of these paintings) meant endless back and forthing between parts. Coaching the elements into a common logic, no matter how illogical, was dangerous work. As with poetry, when sheer inspiration—what is given—gives out, the hard work begins.

And the work was, first and last, *painting*. Knuckles of shapes, errant streaks, repeated sinuous lines, bursts and flares of light, boxed images, halos, were painted with a prodigious variety, indeed virtuosity. The brush was dragged to deposit passages like frayed silk, or sprays of color, then liquidities in which the brush romped in a kind of ecstasy; borders and edges were firmly laid down, then tracked and modified to remove their certainty—all over an underpainting that lurked, disappeared or declared itself according to the task at hand. What paint can do was demonstrated with an

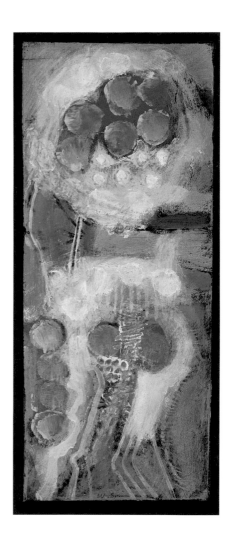

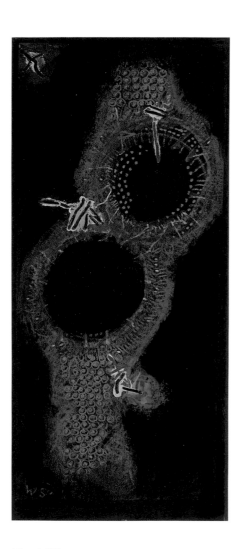

Of Seeded Suns, 1999 *Chronic Wile*, 1999

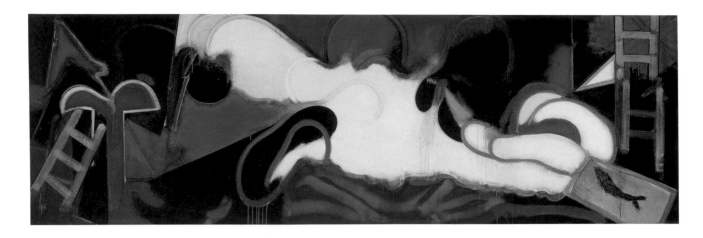

The Important Cloud, 1990, acrylic on canvas, 72 × 208 in., collection of the artist.

extraordinary repertory of means. And attitudes. For the variety
of attitudes was just as rich—from impersonal passages that seemed
to have alighted without intervention, through gentle lyric repetitions,
to thunderous assertions and furnace-like heats. Each painting
incorporated not just different speeds—flashes, hesitations, slow
repetitions—but to have been painted by a variety of personae that
deliberately attempted to eliminate the idea of a single author who,
departing, had left behind a dream of unity.

Recognitions in these paintings are usually scanty. *The Important
Cloud*, over seventeen feet wide and six feet high, is more forthcoming
than most. A light organic shape drifts across most of the canvas,
ascending from right to left. On each end is a ladder. A fish is set like
a signature on the lower right, islanded in a rectangle. Above two
lines cross (a cross?). A triangle rides in atmosphere at the upper left.
The cloud presses against limiting edges from other shapes. But this
description is an inventory and about as useful. Where to find the

origins, the accretions of meaning that have been altered, occluded and turned into pulses of poetic energy?

Several drawings precede and accompany each painting. Scharf draws constantly, amusing himself informally with line-drawings of strange hybrids and bestiaries that are always witty and sometimes very funny. One drawing for *The Important Cloud* is particularly telling. The shapes are all there, obviously in transit to a next stage. A line points from several shapes to a word. Were these words a set of linguistic nodes that clarified the painting's purpose? And if so, what did they uncover of motivation, impulse, process? What was the relation, if any, between these annotations—each of them an idea as well as a noun (one is a gerund)—and the ongoing process? In that marvelous circuit that painterly painting, in particular, involves, the idea feeds the hand and feedback instructs the idea. Put these words together and they read: *menacing, throat, cross, galaxy, ladder, triangle of a new day, cloud swimmer, halo, fish, scaffold, catafalque, mantel (?)*. Floating in space below the drawing, in capitals, the word FEAR. To the left: *cerise, chalice cover*. Below again to the right is a vertical list:

blood / ynstir / bluid / sang / sank / blade / sap / indred / cruor / serum.

This list is more revealing of the master-ideas driving the picture; and its neologisms—ynstir, indred, cruor—to my mind signify either playfulness, experiment, shunting of two languages together, or compression of images to send another compound idea down that painterly circuit to the hand. Whatever the answers that take us in the vicinity of meaning, we are in the company of a painter to whom language and the language of painting can compress the sign (image and/or noun) to yield metaphor, which then initiates those symbolic and signifying runs that activate a set of contingencies to yield allegories. That much is obvious. But allegories of what?

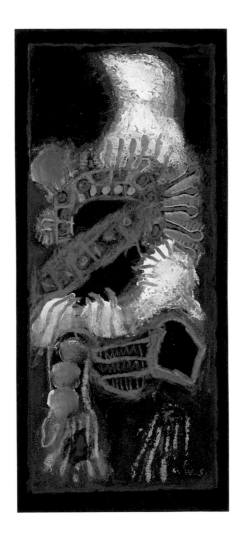

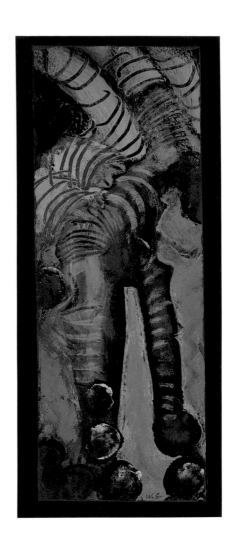

Whose King Am I? 1999

Copper Honor, 1999

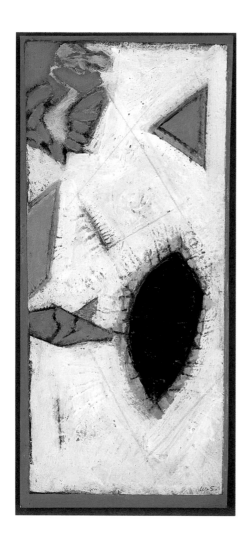

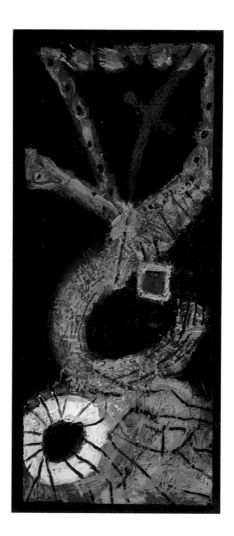

Eyeheart of the Paintress, 1999–2000

In Shield Light, 1999–2000

Perhaps there is another clue in the strange "ynster." It is close to "youstir" which means "foul blood." The list then, is consistent; it seeks different vectors to send through a vision of liquidities, blood, circulation. The fish signature reassures us we are in the proper aqueous environs. The repeated ripple below confirms the notion of currents, circulation. The sacculated cloud, half liquid bubble, half inflated air, rises from right to left through the fluid matrix—the note, *cloud swimmer*, exactly describes its ambiguous status between air and water. It also—for each shape must speak in several voices—looks like a vast amoeba, thereby harvesting again the idea of primitive beginning. The flanking ladders, always, to my knowledge, gerunds for "ascending," are doubled to the right, like a hyphen in the upward relay. The images in the upper half of the painting confirm the notion of rising—the halos at the center; the triangle (*triangle of a new day* in the notated drawing), a cross that is a mark not a religious association. That triangle in the upper left speaks to the fish in the lower right, and they speak the theme of the painting—the ascent from liquid depths to air and atmosphere, which, in the relay system that every successful poem ignites, becomes the image of the creative process realizing itself in that important cloud's upward drift, a cloud that now is almost brain-like—an image of thinking. And all taking place in an organic universe, where the only "hard" thoughts are the rectangle of the fish and triangle of the new day—itself another beginning. What we have here, very precisely, is a scenario enacted in that medium familiar to one variety of surrealism—the aqueous substance that signified poetic potency. Here it becomes the avatar of an undreamed of amplitude and richness.

A good title is like an address. It points you in a direction where you expect a welcome, or at least a recognition. Without its title, Giacometti's *Palace at 4 A.M.* wouldn't have the same imaginative co-efficient that it has with it. Such is our fear of the wordless that

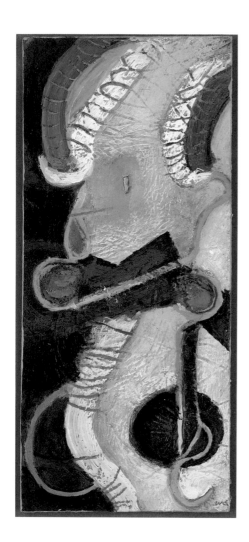

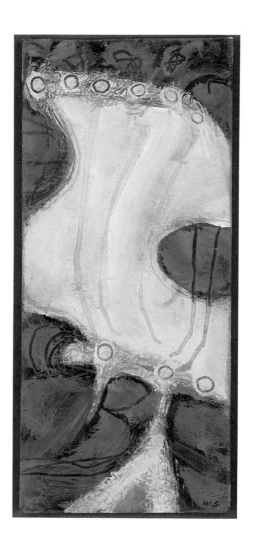

Saints Night Prisoner, 2000

Alee of Vikings, 2000

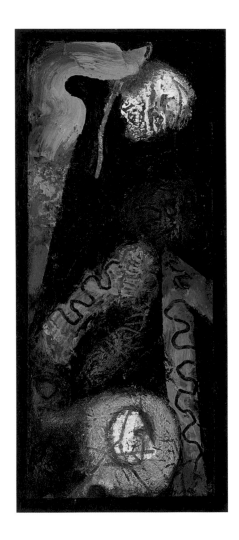

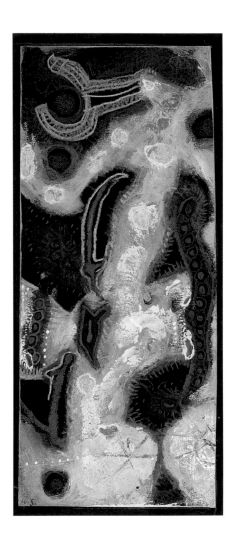

Cure Curve, 1999–2000

Up the Quintain, 1999–2000

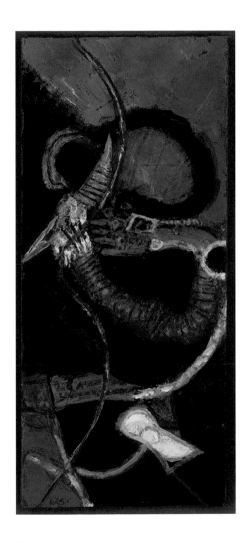

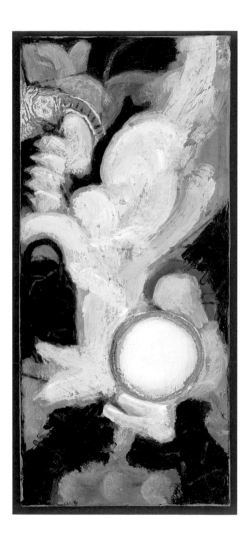

The Red Bow, 2000

A Letter to Among, 2000

the spin a title puts on our thinking as we traverse a painting becomes almost indispensable. When the marriage of title and painting has been sanctioned by time, it cannot be undone. A good title becomes as effective as a shape within the painting, indeed becomes a shape itself. It continues the painting's narrative, becomes as much part of it as anything within the painting, and as generative. Scharf's titles work in this way: *A Quandary of Relics. The Night is in the Middle. The Sun Swimmer* (again the marriage of air and water). *Unused Annunciation. Ascending Betrayal.* What do these titles mean? How do they jump inside the paintings they christen to set off the runs of signification that, like poetry, offer those elusive meanings that poetry cannot approach directly without destroying them?

In providing the answer we can only indicate a climate, not offer a guidebook. The climate is one that has a history. As a painter of Scharf's generation once said of a painting of this persuasion, it (the painting) does not *mean* something, but it has a meaning. Things go out of fashion. The unconscious is not now greatly prized. But its history in art is a powerful one. It involves staying in touch with our curiously arbitrary companions—dreams, again not a fashionable posture now. But two great generations—the surrealists and the abstract expressionists in their early adventures—stayed in close touch with their dream life. Picasso, at certain stages of his multiform career, processed his dreams endlessly. The early work of Pollock, Gottlieb and Rothko locates itself in the vicinity of the dream's mysterious données. This way of thinking survives vigorously in much South American fiction, where life—and death—are too assertive to encourage formalist indulgences. It is a way of going beyond those limiting notions of identity and selfhood by tapping into the puzzling diversity of personae we all possess, while keeping their mystery undischarged. It involves maintaining, exaggerating, and rationalizing mysteries—processing one's life in a way that became not just a

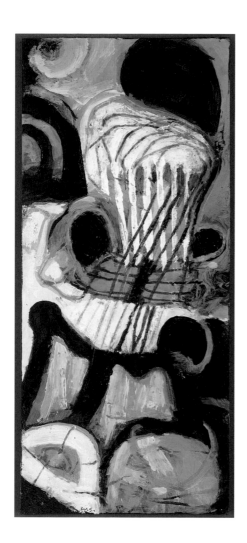

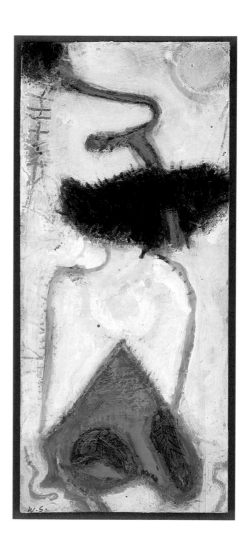

A Poet's Reaping: To Samuel Palmer, 2000

Jungle Leaf Prisoner, 2000

way of thinking but, for a time, a lifestyle. Its monument in modernist literature is that bible of Pollock and others, *Finnegan's Wake*; in there, we watch as a wide range of meanings are compressed into a single word which, in propinquity with others, ricochets across personal and cultural memory, languages and myths.

This is the habit of mind brought consistently through three decades by Scharf, and amplified, in a slow and magisterial development, into majestic paintings. We have here then, not just something unusual, but a lonely journey now full of the triumph of arrival. If we put these laterally extended canvases together in a vast panorama, what does it tell us? What is the narrative of these paintings? We look at them, I think, with a short eye and a long eye—a way of saying that the spaces they colonize are those of organic minutiae on the one hand and, on the other, of those silences and distances Pascal spoke of. As that panorama wheels slowly before us, what do we see? An organic paradise—cells, magnifications of organic fragments, biomorphs, scenarios of metamorphosis, archetypes, fish; distances—a sky with sudden surprising windows into a further sky; a cacophany of signs in which occasional squares reside like authorial escutcheons— all set in those life-giving elements of air and water. However multiform in its articulation, this narrative speaks again and again to a major theme—the origin, the beginning, the moment when things are formed both in nature and the mind, so that the creative process is mirrored and doubled as fictions of identity—supported by dreams—interpenetrate the fictions of reality given us by the long and the short eye.

Chronology

1927 Born in Media, Pa.

1937 Shows drawings to N. C. Wyeth at Chadds Ford. Wyeth encourages him and gives him art supplies. Stays in touch until Wyeth's death.

1938 Starts classes on Saturday mornings at the Philadelphia Graphics Sketch Club, where he is the youngest student. Inspired by an illuminated sign of a can of Sherwin-Williams red paint being poured onto the world.

1944 Graduates from Media High School. Turns down a football scholarship to the University of Utah. Works as an assistant tree surgeon and lifeguard to earn money for art. Begins study at the Pennsylvania Academy of the Fine Arts. N. C. Wyeth writes recommendation: "This boy has the stuff." Studies under Franklin Watkins, Daniel Garber, and Walter Stuempfig. Begins discipline of drawing every morning in a notebook. Spends much time alone drawing at the Philadelphia Museum of Art. Makes sketches for Jasper Deeter at Hedgerow Theater in Rose Valley, Pa.

1945 Enters the U.S. Army Air Corps.

1946 Returns to the Pennsylvania Academy of the Fine Arts. Begins long, solitary walks in the early morning. Exhibits in Philadelphia in group shows at The Philadelphia Art Alliance and The Philadelphia Print Club.

1947 Studies art with Abraham Chanin at the Barnes Foundation, Merion, Pa. Included in the annual exhibition of the Pennsylvania Academy of the Fine Arts in Philadelphia. Marries Diana Denny. William Denny Scharf born December 27.

1948–49 Included in two-person exhibition at the Dubin Gallery in Philadelphia. Receives the Cresson Traveling Scholarship from the Pennsylvania Academy of the Fine Arts. Goes to Paris and studies at the Académie de la Grande Chaumière. Travels to Italy, Belgium, and England. In England becomes friends with Leslie Illingsworth of *Punch* magazine, to whom he sells drawings. Takes classes at the University of Pennsylvania in 1949.

1949 Dances with Shirley Temple at Harry Truman's inaugural ball.

1950 Reenters the Pennsylvania Academy of the Fine Arts, where he has a one-person exhibition. Spends many evenings in jazz clubs sketching. Becomes friendly with Dizzy Gillespie.

1951 Divorced. Goes to sea working on a tanker that travels to Pennsylvania, Texas, and South America. Continues sketching in notebooks and reading William Butler Yeats. On return earns money as a clown diver in an acquacade and as a lifeguard in Florida.

1952 Moves to a studio in New York City above Jimmy Ryan's, a New Orleans nightclub on West 52nd Street; falls asleep each night to "When the Saints Come Marching In." Meets New Orleans clarinetist Omar Simeon. Begins work as a guard at the Metropolitan Museum of Art with artists John Hultberg and Charles Brady.

1953 Moves to West 53rd Street studio next to the Museum of Modern Art. Gets a job as a guard at MoMA and later teaches in Victor D'Amico's classes. Becomes close friends with Dorothy Miller and Mark Rothko. Rothko introduces him to other artists as "my young colleague." Also becomes friends with the photographer Jack Manning, the artist Julius Hatofsky, and the jazz musician Willie Dennis. Devotes his lunch hour to read to Abraham Walkowitz, who is going blind. Becomes friends with other artists downtown at the Cedar Street Bar, including Franz Kline and Willem de Kooning. Meets Stuart Davis, who mentions him in his notebooks.

1954–57 Exhibits in New York City in small group shows at the John Meyers Gallery, Poindexter Gallery, Avante Garde Gallery, and the Heller Gallery.

1956 Marries Sally Kravitch, an actress, whose stage name is Sally Jessup. Mark Rothko is best man and his wife Mel is matron of honor; the reception is held at the Rothkos' apartment. Included in the American Federation of Art's "Museum Director's Choice," traveling group exhibition.

1958 Work included in group exhibitions at the University of Illinois Annual in Urbana, Ill., the Symphony Hall Guild in Boston, Mass., MoMA in New York City, the Institute of Contemporary Art in Boston, Mass., the Houston Museum of Contemporary Art in Texas, as well as the American Federation of Art's "New Talent" traveling exhibition.

1959 Appears on Broadway as a reporter in *The Andersonville Trial*. Drawings published in the *New York Herald*. Included in an exhibition at the National Gallery in Dublin, Ireland.

1960 Has first one-person exhibition in New York City at the David Herbert Gallery.

1961 Artwork selected by Thomas Messer for the Boston Institute of Contemporary Art. Given the May Audubon Post Award at the Pennsylvania Academy of the Fine Arts.

1962 Has second one-person exhibition at the David Herbert Gallery and shows for the first time at the American Gallery in New York City. Exhibits in the National Gallery in Dublin, Ireland, as well as at the University of Illinois Annual in Urbana.

1963 Begins teaching painting and drawing at the San Francisco Art Institute. Included in exhibitions at Brandeis University in Waltham, Mass., and at the Aldrich Museum in Ridgefield, Conn.

1964 Has one-person exhibition at the Griffin Gallery in New York City. Begins assisting Mark Rothko on preliminary studies for the De Menil Chapel in Houston, Tex. Moves into a studio on Columbus Avenue in New York City. Teaches painting and drawing at MoMA's Art Center. Aaron Anderson Scharf born February 25.

1965–69 Teaches painting and drawing at the School of Visual Arts, New York City.

1966 Meets Robert Beverly Hale, Curator of American Painting at the Metropolitan Museum of Art, who becomes a close friend.

1966–85 Begins working during the summer at Tybee Island, Ga., in the former studio of Alexander Brook. Next year finds space in an abandoned cotton warehouse in Savannah, Ga., on the river. Divides time there with teaching at the San Francisco Art Institute and the School of Visual Arts in New York City. Starts scroll paintings titled *Continuum* in river studio. Meets poet Conrad Aiken. In San Francisco has studio above Harrington's Bar on Front Street and exhibits first series of *Continuum*.

1967 Travels to Paris to see Picasso exhibition, then to Dublin and London.

1969 Teaches painting and drawing at the San Francisco Art Institute.

1970 Travels to Leningrad, Kalinin, and Moscow to study icons.

1973 Shows in small group exhibition at the Martha Jackson Gallery in New York City.

1974 Teaches painting and drawing at the San Francisco Art Institute. Gives guest lectures at Stanford University, Palo Alto, Calif., and the California College of Arts and Crafts, San Francisco.

1976 Has one-person exhibition of *Continuum* scrolls (covers 3,000 square feet) at the Neuberger Museum in Purchase, N.Y. Included in group exhibitions in Brussels, Belgium at Galerie Alexandra Monett and Les Ateliers du Grand Hornu Galerie d'Art. New York attorney general appoints him to serve on the board of the newly created Rothko Foundation.

1977 Has one-person show of *Continuum* at the Lerner-Heller Gallery in New York City.

1978 Exhibits *Continuum* at the High Museum of Art in Atlanta, Ga. Included in three-person exhibition at the Gurewitsch Gallery in New York City, and also at Smith-Anderson Gallery in Palo Alto, Calif. Acts as guest curator for the Solomon R. Guggenheim Museum's Rothko retrospective exhibition.

1979 Exhibits at the Smith-Anderson Gallery in Palo Alto, Calif. Gives a guest lecture at Pratt Institute, New York City.

1980 Travels to Greece and works on notebook drawings. Exhibits at the Summit Art Center in Summit, N.J. and at Hirschl & Adler Galleries in New York City.

1982 Travels to London and St. Ives in Cornwall; continues to work on notebook drawings.

1985 Displaced from Savannah studio when it is gentrified into an inn. Finds studio in New York City on West 68th Street. Becomes friends with artist Esteban Vicente. Has one-person exhibition at Saint Peter's Church in New York City.

1987 Has one-person shows at the Armstrong and the Elizabeth Bartholet Galleries in New York City and the Brownson Gallery at Manhattanville College in Purchase, N.Y. Begins teaching painting and drawing at the Art Students League, New York City, where he still teaches.

1989 Travels to England and works on notebook drawings. Teaches painting and drawing at the San Francisco Institute of Fine Arts.

1993 Has one-person exhibitions at the University of Michigan Museum in Ann Arbor, Mich., and the Zimmerli Museum at Rutgers University.

1994 The Phillips Collection, Washington, D.C., acquires *The Night Is in the Middle*. In 1995 he gives the museum eight studies for it; in 1996 he gives four more studies for it.

1994–99 Begins painting in Vinalhaven, Maine.

1996–99 Included in group show at the Anita Shapolsky Gallery in New York City.

2000 Included in four-person show at the Anita Shapolsky Gallery and *League Masters Now* at the Art Students League, New York City.

One-Man Exhibitions

1993 University of Michigan Museum of Art, Ann Arbor, Mich.

1987 The Armstrong Gallery, New York, N.Y.

1987 Saint Peter's Church, New York, N.Y.

1987 Manhattanville College, Purchase, N.Y.

1985 Saint Peter's Church, New York, N.Y.

1984 Mississippi Museum of Art, Jackson, Miss.

1982 Mississippi Museum of Art, Jackson, Miss.

1979 Lerner-Heller Gallery, New York, N.Y.

1978 High Museum of Art, Atlanta, Ga.

1976 Neuberger Museum, Purchase, N.Y.

1969 San Francisco Art Institute, San Francisco, Calif.

1964 Griffin Gallery, New York, N.Y.

1963 Zabriskie Gallery, Provincetown, Mass.

1962 The American Gallery, New York, N.Y.

1962 David Herbert Gallery, New York, N.Y.

1960 David Herbert Gallery, New York, N.Y.

1950 Dubin Gallery, Philadelphia, Pa.

Group Exhibitions (Selected)

2000 *The Twenty-Fourth Annual National Invitational Drawing Exhibition*, Emporia State University, Emporia, Kans.

1999 *Artists/Mentors*, Denise Bibro Gallery, New York, N.Y.

1998 *Self-Portraits*, Art Students League, New York, N.Y.

1996 *Hot Art*, Anita Shapolsky Gallery, New York, N.Y.

1994 *X Sightings*, David Anderson Gallery, Buffalo, N.Y.

1993 *American Painterly Abstraction*, Zimmerli Museum, Rutgers University, New Brunswick, N.J.

1992 *The Fifties, Part Two*, Anita Shapolsky Gallery, New York, N.Y.

1980 *The Papier*, Summit Art Center, Summit, N.J.

1973 *New Images*, Martha Jackson Gallery, New York, N.Y.

1957 *Five Contemporaries*, Avant Garde Gallery, New York, N.Y.

1956 *Twenty-One Americans*, Poindexter Gallery, New York, N.Y.

1955 *Four Young Americans*, Poindexter Gallery, New York, N.Y.

Public Collections (Selected)

Boston Institute of Contemporary Art,
 Boston, Mass.
Bradford Bank, Boston, Mass.
Brooklyn Museum, Brooklyn, N.Y.
Carnegie Corporation of New York,
 New York, N.Y.
Chase Manhattan Bank, New York, N.Y.
Colgate University, Hamilton, N.Y.
Dennos Museum Center, Northwest Michigan
 College, Mich.
Hobart College, Geneva, N.Y.
Hudson River Museum, Yonkers, N.Y.
J. Patrick Lannan Museum, Venice, Calif.
Mercer College, Mercer, Pa.
Mississippi Museum of Art, Jackson, Miss.
Museum of Modern Art, New York, N.Y.
Nassau County Museum of Fine Art, Roslyn, N.Y.
National Museum of American Art (Smithsonian),
 Washington, D.C.
Neuberger Museum, Purchase, N.Y.
Newark Museum, Newark, N.J.
The Phillips Collection, Washington, D.C.
Rockefeller University, New York, N.Y.
Rutgers University, New Brunswick, N.J.
Smith College Museum of Art,
 Northampton, Mass.
Solomon R. Guggenheim Museum,
 New York, N.Y.
Telfair Museum, Savannah, Ga.
The High Museum of Art, Atlanta, Ga.
The Neurosciences Institute, San Diego, Calif.
The School of Visual Arts, New York, N.Y.
UniDynamics Corporation, Stamford, Conn.
University of Michigan Museum of Art,
 Ann Arbor, Mich.
University of Northern Iowa, Cedar Falls, Iowa
University of Pennsylvania, Philadelphia, Pa.
Warburg, Pincus Co., Inc., New York, N.Y.
Winston-Salem Museum of Art,
 Winston-Salem, N.C.
Yale-New Haven Hospital, New Haven, Conn.

Published References (Selected)

"About Art and Artists." *New York Times*, 21
 December 1955.
"Americans to Watch in 1965." *Pageant* (1965): 91.
"An Artist's View of His Fellow Actors."
 New York Herald-Tribune, 1 May 1960.
"Art and the River." *Savannah-News Press*,
 14 August 1983.
Ashton, Dore. "Exhibition at the American Gallery."
 Arts and Architecture 79 (December 1962).
Ashton, Dore. "Art: Visions by Scharf." *New York
 Times*, 13 January 1962.
Beals, Katie. "Art Bursts with Vitality." *Westchester
 Rockland Newspapers*, 18 June 1976.
Brown, Tony. "Acclaimed New York Painter Finds
 Refuge on Factor's Walk." *Savannah Morning
 News-Evening Press*, 14 August 1983.
Chanin, Abraham. Introduction. In *David Herbert
 Gallery Catalogue* (New York: David Herbert
 Gallery, 1960).
Collage/Assemblage (Summit, N.J.: Summit Art
 Center, 1980), 21.
DeKay, Ormande. "Bill Scharf's Drawings."
 Art World 12 (November–December 1987): 8.
Directory of Contemporary Prints, s.v., "Scharf,
 William." 1985.
Edelman, Gerald M. "The Wordless Metaphor:
 Visual Art and the Brain." In *Biennial
 Exhibition Catalogue* (New York: Whitney
 Museum of American Art, 1995), 42–43 (illus.).
Forecast (Lerner-Heller Gallery, New York, 1979,
 exhibition brochure).
Green, Roger. "Scharf Exhibit Affirms Vitality of
 Abstract Art." *Ann Arbor News*, September
 1993.
Hooten, Bruce. "The New Show in Sculpture
 and Painting." *New York City News*,
 18 September 1978.
Judd, Donald. *Complete Writings 1959–1975*
 (New York: New York University Press, 1975).
Kozloff, Max. "New York Notes," *Art
 International* 6 (February 1962): 71.
Linea: Journal of the Art Students League 3
 (summer 1999).
Kramer, Hilton. "Art: A Continuum of Energy."
 New York Times, 30 July 1976.
Manning, Jack. *The Fine 35mm Portrait* (New
 York: American Photographic Book Publishing
 Co., 1978), cover, 46.

Matthew, Ray. "William Scharf at St. Peter's." *Art
 World* 9, no. 7 (1985): 12.
Mellow, James R. "Four Paintings at the
 Poindexter Gallery." *Art News* 55 (1956): 80.
Mellow, James R. "Freshness vs. Seasoning: Two
 Schools of Thought." *New York Times*, 1974.
O'Doherty, Brian. "Art: Three Studies in Free
 Association." *New York Times*, March 1960.
O'Doherty, Brian. *New York Times*, 30 May 1964.
O'Doherty, Brian. *William Scharf* (Ann Arbor:
 University of Michigan Museum of Art, 1993).
People Magazine, 30 November 1987, 128 (illus.).
Raynor, Vivien. "New York Exhibitions." 36
 Arts Magazine (February 1962): 38.
Tillim, Sidney. "Exhibition at the Herbert
 Gallery." *Arts Magazine* 34 (April 1960): 57.
"New Talent in the United States." *Art in America*
 46 (spring 1958): 22 (illus.).
University of Illinois Catalogue (Urbana:
 University of Illinois, 1961), 200.
Vigtel, Gudmund. *High Museum Catalogue*
 (Atlanta: High Museum of Art, 1978).
Who's Who in America, 45th ed., s.v., "Scharf,
 William." 1988–89, 2733.
Who's Who in American Art, s.v., "Scharf,
 William." 1978–2000.
Who's Who in the East, 21st ed., s.v., "Scharf,
 William." 1986–87, 709.

Checklist

Paintings on canvas

Cerebration, 1984
Acrylic on canvas, 69 × 111 in.
Collection of Kate Rothko Prizel and Ilya Prizel
Page 4

Bruised Emanation, 1984
Acrylic on canvas, 62 × 70 in.
Collection of Gavin Zeigler and Sonia Toledo
Page 8

Pink Annunciation, 1985
Acrylic on canvas, 56 × 108 in.
Collection of the artist
Page 12

The Night Is in the Middle, 1986
Acrylic on canvas, 72 × 209 in.
The Phillips Collection
Anonymous gift, 1994
Page 16

Sphynx Cloud, 1992
Acrylic on canvas, 76 × 103 in.
Collection of the artist
Page 10

By Mirrored Meaning, 1993
Acrylic on canvas, 63 × 39 in.
Collection of the artist
Page 14

Stigmata of the Thorns, 1993
Acrylic on canvas, 66 × 80 in.
Collection of the artist
Page 18

Shields of Falsity, 1993
Acrylic on canvas, 69 × 58 in.
Collection of the artist
Page 21

Apotheosis of the Wing, 1995
Acrylic on canvas, 66 × 54 in.
Collection of the artist
Page 23

Above the Milk Sphynx, 1994–98
Acrylic on canvas, 68 × 46 in.
Collection of the artist
Page 25

Bejeweled Rite, 1996
Acrylic on canvas, 66 × 34 in.
Collection of the artist
Page 27

Orchard of Fables, 1998
Acrylic on canvas, 68 × 46 in.
Collection of the artist
Page 29

The Martyrs Ladder and the Harm Angel, 1998–99
Acrylic on canvas, 69 × 46 in.
Collection of the artist
Page 31

Paintings on board

Of Valued Folly, 1989
Acrylic on board, 11½ × 14⅞ in.
Collection of the artist
Page 32

Grey Moon, 1991
Acrylic on board, 11¾ × 14⅞ in.
Collection of the artist
Page 34

Hate Lifter, 1991
Acrylic on board, 11½ × 14¾ in.
Collection of the artist
Page 35

Flesh Jail, 1991–94
Acrylic on board, 11¾ × 14⅝ in.
Collection of the artist
Page 37

From Darker Aims, 1994–95
Acrylic on board, 11½ × 14¾ in.
Collection of the artist
Page 38

An Asgardian Again, 1994–95
Acrylic on board, 12¼ × 14⅞ in.
Collection of the artist
Page 39

The Angel Says No to Fra Angelico, 1995
Acrylic on board, 11⅛ × 14⅝ in.
Collection of the artist
Page 41

The Prodigal Daughter Returns for Her Mirror, 1995
Acrylic on board, 11⅛ × 14⅛ in.
Collection of the artist
Page 42

The Denials Defied, 1997
Acrylic on board, 12 × 14 in.
Collection of the artist
Page 43

The Sun Blued Moss, 1997
Acrylic on board, 11¾ × 15 in.
Collection of the artist
Page 45

A Phoenix for Finding, 1998
Acrylic on board, 12 × 15 in.
Collection of the artist
Page 47

Wind Oval, 1998
Acrylic on board, 12 × 15 in.
Collection of the artist
Page 48

Works on Paper

From Blind to Broken, 1999
Acrylic with pencil on paper, 9 × 4 in.
Collection of the artist
Page 51

The Cancelled Ladder, 1999
Acrylic with pencil on paper, 9 × 4 in.
Collection of the artist
Page 51

Under a Rightening, 1999
Acrylic with pencil on paper, 9 × 4 in.
Collection of the artist
Page 53

The Profaned Fleece, 1999
Acrylic with pencil on paper, 9 × 4 in.
Collection of the artist
Page 53

Of Seeded Suns, 1999
Acrylic with pencil on paper, 9 × 4 in.
Collection of the artist
Page 55

Chronic Wile, 1999
Acrylic with pencil on paper, 9 × 4 in.
Collection of the artist
Page 55

Whose King Am I? 1999
Acrylic with pencil on paper, 9 × 4 in.
Collection of the artist
Page 58

Copper Honor, 1999
Acrylic with pencil on paper, 9 × 4 in.
Collection of the artist
Page 58

Eyeheart of the Paintress, 1999–2000
Acrylic with pencil on paper, 9 × 4 in.
Collection of the artist
Page 59

In Shield Light, 1999–2000
Acrylic with pencil on paper, 9 × 4 in.
Collection of the artist
Page 59

Cure Curve, 1999–2000
Acrylic with pencil on paper, 9 × 4 in.
Collection of the artist
Page 62

Up the Quintain, 1999–2000
Acrylic with pencil on paper, 9 × 4 in.
Collection of the artist
Page 62

The Red Bow, 2000
Acrylic with pencil on paper, 9 × 4 in.
Collection of the artist
Page 63

A Letter to Among, 2000
Acrylic with pencil on paper, 9 × 4 in.
Collection of the artist
Page 63

Saints Night Prisoner, 2000
Acrylic with pencil on paper, 9 × 4 in.
Collection of the artist
Page 61

Alee of Vikings, 2000
Acrylic with pencil on paper, 9 × 4 in.
Collection of the artist
Page 61

A Poet's Reaping: To Samuel Palmer, 2000
Acrylic with pencil on paper, 9 × 4 in.
Collection of the artist
Page 65

Jungle Leaf Prisoner, 2000
Acrylic with pencil on paper, 9 × 4 in.
Collection of the artist
Page 65